Living with Purpose
When the Gods
Are Gone

Robert P Crosby

© 1991, 2014 by Robert P Crosby

Freddie Baer graciously donated layout and design work.

Cover art by William Blake

Edited by John Hanlen

Library of Congress Cataloging-in-Publication Data

Crosby, Robert P, 1928-
Living with Purpose When the Gods Are Gone
Robert P Crosby. p. cm.
Includes bibliographical references.
ISBN 0-87810-038-5 : $5.95

1. Humanist ethics. BJ1360.C76 1991

I. Title.

171'.2--dc20 91-18681
CIP

Vivo! Publishing Co., Inc.

This book is dedicated to
Ross Snyder, Ruth Emory, *and* **Rene Pino**

*"I do not accept any absolute formulas for living.
No preconceived code can see ahead to everything
that can happen in a man's life. As we live, we grow
and our beliefs change. They must change.*

*So I think we should live with this constant discovery.
We should be open to this adventure
in heightened awareness of living.*

*We should stake our whole existence
on our willingness to explore and experience."*
- Martin Buber

<u>Table of Contents</u>

Preface

Ross Snyder taught at Chicago Theological Seminary from 1941 until about 1977. He inspired "Essay Four" which is the heart of this book.

He represents a style of teaching that celebrates education as an event more than just the passing of knowledge. For him, teacher and student are two humans exploring meaning together. My most vivid memory of a Ross Snyder "lecture" at a conference was to see him on stage with several young people, sharing personally, authentically, and with sharp intelligence about the meaning of their lives.

To quote him freely, "Life is meant to be lived. All of us are meant to be participants, not merely spectators. Organizing a life-world and taking it someplace is what life is all about. It is the goal that includes all other goals."

Ross Snyder is a pioneer in new and unusual approaches to religious education and uses language in ways that are profoundly disturbing and very evocative. In retirement, he lives in California.

Ruth Emory, source of the above information, was Snyder's student from 1957 to 1959. A powerful teacher in her own right, she credits him with inspiring concepts that continue to enlighten her everyday experience. She says, "These ideas work in my organizational consultation, my choir directing, my piano teaching, and just all the time!"

In 1964-65, on leave from the youth staff of the Methodist Church (USA), Ruth served on the youth department staff of the World Council of Churches in Geneva. There she edited materials based on Snyder's concepts for worldwide distribution.

Her own adaptations, in her paper "A Point of View for Participating in a Ministry with Youth," were the basis of countless training sessions of youth workers. Quotes from that paper are in "Essay Four."

Currently she and Rene Pino are co-administrators of the Organizational Development Network with offices in Portland, Oregon.

Rene, Ruth, and I spent many empowering and clarifying days together as colleagues in the 1960s. Rene's creative ideas stimulated both new understandings and applications to youth-worker training programs. Many ideas in this book were forged in the crucible of our conversations. I am grateful to them.

I also appreciate others who helped make this book a reality. These include my wife and coworker Patricia and friends Caryl Hurtig, Melisa Stowe Noel, Ron Siddel, and Scott Smith, all of whom gave me suggestions and encouragement. Becky Clarno did a fine job of word processing, including considerable revising. Wayne Barr, PhD, who taught Old Testament to me at United Theological Seminary in Dayton, Ohio, is now retired from teaching but not from responding graciously and competently to unusual questions phoned in by this former student.

Sally Hoover contributed many valuable suggestions, among them one to include a study guide. George Cairns, minister of urban affairs at Peoples Church, Chicago, read the manuscript submitted to the publisher and made helpful criticism that influenced the final version.

Robert P Crosby
August 1990, Acapulco, Mexico

Introduction

The gods and goddesses are rapidly losing power over humans. In my reality, they never literally existed. But at least they contributed important mythological meanings to generations. Images of these deities as literal beings provided a mooring for millions of humans in countless cultures. With the decline of faith in supernatural gods and goddesses, we stand at the edge of an amazing time of hope! Finally, we humans can base our values on a human reality, not a fantasy of supernatural revelation. Perhaps we can cease going to war to impose our fantasies on others.

This book is about an alternative to political and religious "true belief." While it would not be described as an autobiography, it feels that way to me.

My journey began in 1928 in a town of 3,000 people in Western Pennsylvania. Dad had grown up on the farm, fought in World War I, and returned home to marry the daughter of a "perfect Christian" mother. He worked on the Pennsylvania Railroad while Mother raised two sons in an immaculate house. A plaque in our home read, "Cleanliness is next to Godliness." (When Mother was 89 and nearly blind, she could still see "lint" on my sweater and move her hands directly to it as if she possessed an internal radar system.) They had grown up in very conservative Protestant Christian homes. In the 1920s, they had joined the northern arm of the Ku Klux Klan and continued to defend that "fine Christian group" until about 1941, when a school teacher influenced me otherwise and my parents opened themselves to a new view of the KKK. My parents became so ashamed of that former association that they asked me not to mention it to anyone. (Sorry, Mother and Dad, but that history is too significant for me to deny or hide.) While remaining theologically conservative all of their

lives, they became supportive of social causes such as civil rights and were among the first to join Roman Catholics for ecumenical study when Pope John opened the windows in the early 1960s.

My distant heroes growing up were Gandhi, Kagawa (a Japanese pacifist), and Albert Schweitzer. Schweitzer's book, *The Quest for the Historical Jesus* (published in 1898)—which reinforced the resolve of his sponsoring European missionary society to ban him from preaching to his African patients, later influenced me.

In the early 1950s, I was deeply involved with such questions in religious education as, ''Do we blindly pass on the faith? Or do we encourage critical thinking about our religious beliefs and traditions?" As a youth worker in the late fifties, I encountered the same questions in the public sphere, conceptualized as values *push* vs. values *exploration*. It seemed clear that values push was the norm and a clear expectation for youth workers. "Parents don't hire you to 'explore' values about sex with youth except, of course, if that's your subtle way of pushing the right answer!"

Values exploration was and is an attempt to help persons be more aware of alternatives, resources, and skills needed to choose new options effectively. Such an exploration encourages a careful listing of both the positive and negative consequences of each proposed alternative. The goal is informed individual choice.

A key assumption is
individuals do indeed make choices;
these choices are *more likely to be wise*
if these persons are fully aware
of options and consequences.

These essays are written in the spirit of you "becoming your own guru." I do, however, briefly reference "commitment to community" in the fourth essay. My own journey has been with others—not alone. Mentors have both confronted and nurtured me: peers in religious, professional, and issue-oriented communities have enriched my life. I cannot imagine succeeding on such a journey alone or without the influence of historical tradition. Such a journey, in concert with others, is imperative today.

It is to be hoped that the seemingly inevitable development of society, beyond family, tribe, city-state, and nation to planet, is nearing this final stage. Nations developed as results of economic and population pressures, dynastic aspirations, wars, popular revolts, and geopolitical maneuvering. Dogmatic theologies and political ideologies supported separateness and encouraged confrontation. We in the twentieth century are not strangers to the resulting tragedies. Examples abound, include Hitler's fascism (an extreme of nationalism); Stalinist communism; apartheid (supported by Christian fundamentalism); the Iran/Iraq War (secularism vs. Islamic fundamentalism); the Holy Land impasse (competing nationalisms, fueled in part by Christian, Jewish, and Muslim fundamentalism and great-power maneuvering); and, most recently, the war over Kuwait against Iraq involving no end of nationalist, religious, and economic antagonisms which resulted in great human and ecological destruction.

The dogmatism underlying such conflicts is no longer viable, but persists all the same. It seems clear that
*human beings need **principles***
*around which to **organize** their daily life **decisions**.*
<u>*Dogma not examined promotes further conflict.*</u>
These essays are about a search for living principles.
It is imperative that we let go of belief systems which inhibit

3

us from being the planetary people that we can dare to be. Toward that end, we must create organizing principles for this time. I attempt to lay the groundwork for such creativity in the first three essays. I intend the fourth and fifth essays to illustrate such principles.

The gods have fallen
The world is round
The faithful listen
There is no sound
 But the ever-shifting ground.

Where, oh where, may truth be found?
First , truth itself must go through fire
Be purged of the romance desire
That it be consummate and pure
False promises that reassure
This embossed version shall endure!

Then, only then, can truth be found
 Ironically—on shifting ground.

The deep, deep sigh for you, for me
Comes when we quit so frantically
Chasing goblins for the word
And find our peace in the absurd.

For truth, like standing on the sand
. . . ankle deep, twixt sea and land Is beauty, fear,
tide in, tide out
A swell of joy, a pang of doubt.

<div align="right">- Robert P Crosby</div>

Vs 1: May 1978 (Mykonos, Greece)
Vss 2-4: February 7, 1979 (Olympia, WA)
Vs 5: August 1979 (Hawaii)

4

Essay 1
Transition

Pre-language humans undoubtedly had a sense of wonder and awe at something beyond themselves, in response to ongoing, often unpredictable, natural events. As language developed, everything from birth to death, from eclipses to floods, was identified and probably explained or interpreted. It seems that language itself had to become highly developed before causal understanding could come about, so the first views of life must have been magical.

Some people were probably more adept at explanation and prediction than others and they thus became revelations of gods. Physically-felt awe led to intellectual certainty. Of course, the details of certainty would vary from culture to culture, but within each culture there would usually be spiritual (and perhaps temporal) leaders who were the guardians and enforcers of revealed truth. Some mystics saw beyond the particularities of the local revelation and at the same time managed to exert influence; simple nay-sayers could face anything from ostracism to death for their nonconformity.

The priestly class tended to insist on the power of words. If you uttered a curse against someone, that person might die as a result (just think: in those times the average life span rarely reached 30 years). And the most potent curse or blessing invoked the name of one of the many gods. The gods were everywhere. They lived in the forms of animals, plants, and humans. The earliest human gods, including those of creation, seem to be female (the role of males in reproduction was unknown for ages). Later, patriarchal societies tended to exalt male gods and to limit female gods to the areas of love and fertility.

As language developed and stories were told, the origin of the stories was lost. Soon they were attributed to the gods themselves. Thus, a story that began around a nomadic campfire became one given by the gods at the beginning of time (which was placed only hundreds or thousands of years before).

Many religious and political leaders spoke as if their cultures' interpretations of the mysteries of life were unchanging realities. The myths which dramatized their interpretations became literal historical events. This evolution of the interpretations was not apparent to most before the advent, in the late nineteenth century, of modern archaeological and literary methods.

Fundamentalists in various religions continue to reject new understandings about the historical development of their various beliefs. They cling to their magical beliefs, under the pretext of *special* revelation. Countless numbers have died to promulgate and defend these imagined certainties, including millions in the twentieth century.

I believe we are now living in the transition period between the *Age of Certainty,* with priests empowered to proclaim their own version of the final truth, and an *Age of Courage,* in which the priests are those who help us make sense of our lives in the midst of insecurity, uncertainty, and not-knowing. In our time, both are on the stage of history at once, and often within the same institutions. This essay is written for those who no longer look to authorities for answers, for those who would join the age of courage. It is for those who believe that, if there is an "out there," it cannot be known as final truth by some priest down here or held in a sacred book or creed. It is written for those who have the courage to seek meaning—knowing that they will never know for certain.

Hope and fear, faith and doubt continually recur.

"Always within me there is the rumor that I may be wrong!" Howard Thurman said. "And that is my growing edge!"[1] The Hindu *Upanishads* say: "He who thinks that God is not comprehended, by him God is comprehended; but he who thinks that God is comprehended knows him not." Such a religious tradition has a perspective about the many faces of God missing in the more austere fundamentalist traditions.

On a recent visit to the Greek island of Mykonos, I met Pericles, a man of about fifty. "I am to be baptized into the name Pericles, in the Orthodox Church, but I am not religious." An interesting disclaimer. In its Latin root, *religare* means to bind together as in ligament, or to integrate. To Pericles, I assume it meant to hold a dogmatic, separate, true-belief position.

Christian, Jewish, and Muslim myths are regarded as literal events by many in the Twentieth-century Western world, while the ancient myths of Scandinavia, Greece, Rome, and pre-Colombian America are seen as fables. This fact is ultimately attributable more to military might than historical insight.

On United States coins there is the phrase "In God We Trust." Who is this god? Where is he from? Few would contest that the traditional USA god is male. The founding fathers of the country led a revolution to give freedom to white male property holders. While that dream has since been expanded to include, legally at least, ethnic minorities, females, and persons without property, in the eighteenth century, it was a male dream in a male world with a male god supported by a white-male priestly, military, legal, and financial monopoly.

Many Americans recognize the name of this god: Jehovah. Who is he?

7

The sophisticates will first tell you that a better rendering of his name is "Yahweh." The origin of this god is a subject important to Jews, Muslims, and Christians, since all share a common story beginning with Abraham. ("Allah" is Arabic for god.) What follows summarizes a non-fundamentalist perspective which has widespread acceptance among Biblical scholars.

To make sense out of what you are about to read, you must remember that even the Bible in reporting the Ten Commandments legend has the god saying, "Thou shalt have no other gods before me," not, 'Thou shalt have no other gods." For the Jews of that time there were other gods! The issue was about which one was primary for this Semitic tribe.

Prior to the exodus from Egypt, Moses had met and married a woman whose father, Jethro, was a priest of a storm-god from the south (i.e., Southern Arabia) named Yahweh. Moses submitted to Yahweh, whose power later successfully guided the children of Israel through the wilderness to the Promised Land.

The famous story dramatized by Hollywood in *The Ten Commandments* with Charlton Heston, is the interpretation embellished by storytellers and priests for centuries before being written down. (Of course, Hollywood added its own interpretation.) According to that story, getting the people to change was as difficult as getting people to change beliefs today. When Moses had gone up the mountain to meet with Yahweh (most ancient gods lived high, close to the heavens in a flat-earth, solid-sky world), the people built a golden calf and worshiped the former familiar gods.

This infuriated Moses when he returned. (Yahweh had said, "Don't do that. Don't have other gods before me.") With the

strong sponsorship of Moses, Yahweh was credited as being the god, among competing gods, who guided the children of Israel into the Promised Land.

All who saw the movie *Raiders of the Lost Ark* are acquainted with the powers ascribed to the ark. To the Israelites, this ark, or chest, represented the real presence of Yahweh, and they carried it into battle. This is not just a story made up by a scriptwriter for a twentieth-century movie. The power in that ark emanates from the self-same god in whom "we trust," and under whom we place the nation in the Pledge of Allegiance.

Many centuries after Moses and several centuries before Jesus, a serious rift emerged among the Jews. The traditionalists said that Yahweh was their god and protected them against their enemies who were less adequately empowered by their own tribal or national gods. Others said that Yahweh was the only god and, therefore, also the god of their enemies. Heresy! The Bible reflects both views, but eventually, through a long, arduous, and bloody evolution, the belief that Yahweh was a universal god emerged.

All other gods became idols or myths or legends. Thousands of gods fell. Jupiter fell. Zeus was dethroned. Once the Christians adopted Yahweh and gained military ascendancy, Yahweh became the one, true God wherever Christian military might was victorious. Certainly, the dynamic nature of the concept of Yahweh also contributed to his ascendancy. If he had remained a storm-god or a god of a territory, he would not have succeeded.

The story of Christians conquering much of the world in the name of Jesus (Yahweh's son) and destroying temples and pagan gods as well as other cultures is surely known to

9

most readers. By questionable but ancient logic, the military victories of Christian troops proved Yahweh's might: the same logic utilized by true believers of other faiths. Muslims, Jews, and Christians in the Middle East demonstrate this in their endless battles. In Christian history, the Greek, Roman, Teutonic, Gaelic, Viking, Aztec, Native American, and countless other gods were conquered by Yahweh's Christian troops who brought with them missionaries to spread their one true message to the world.

This one true message, based on the universalizing of the storm-god Yahweh, added the further particular, found in Matthew and Luke of the Christian *New Testament*, that he caused a son to be born in the style of a Greek miracle birth, of a maiden without coitus. This son, through his teachings, self-sacrificing death and resurrection, was seen as the Savior of the world.

Believers in the Yahweh/Jesus/Mary myths have conquered much of the world. Such stories in all religious faiths can be a profound source of wisdom, but fundamentalists literalize them and, thus, place them in competition with modern scientific explanations of origins. A tragedy results from such an unwise competition of myths when pitted against modern science.

More and more people turn away from their traditions. They lose their spiritual base, their moorings, their roots. They then become susceptible to political true-belief movements or despair of finding any value base at all.

The ancient myths are not true or false any more than Shakespeare is true or false, or poetry, philosophy, and parables are true or false. All express truths but are not to be confused with truth as literal fact. Joseph Campbell and many

others have already asserted the power and truth of myths. It does not negate the truth of a myth for it to be held as non-literal. In fact, it frees the myth to be used imaginatively toward deepening one's spirituality.

It does, however, negate religious fundamentalism's grounding in literalness. The essence of *certainty thinking* is that the supernatural not only exists, but also that it has been expressed and formulated into a final truth that is known to, and correctly interpreted by, the priest of some particular brand of fundamentalism. It should be clear to anyone living in the twentieth century that atheism, too, can have its true-believer dogmatic form. Political and economic beliefs also can be held as theories or as the fundamental given-nature of existence. Witness the way both socialism and capitalism have often been described by some adherents as being the inevitable, natural order of life.

It is precisely this claim by mortals to possess *final* truth that must and will be transcended before we become one planet. When we have passed through this transition from the age of certainty to the age of courage, a synergy will occur that will move us to a dynamic stage of existence not yet imagined.

Essay 2
Neither Black Nor White

The primary divisive force in the world and its smaller units
(nations/ organizations/ communities/ families/ companions)
is the belief of some
that *they* possess *the* unalterable formulation of truth.

It is no one's sense of uniqueness that is in question here, but
only claims that such uniqueness can monopolize truth. Such
a claim leads to the idolizing of fixed beliefs. Worse still, it
tends to deny the validity of the faiths and experiences of
all others. These exclusive positions, dysfunctional as they
were in tribal days, are even more destructive as the "art" of
weaponry develops.

This is not a rejection of imaginative faith or hope or values.
Rather, it is an attack on claims to certainty or to the possession
of final truth. This attack is aimed at political, scientific,
philosophical, psychological, economic, religious, or any
other form of human thought which is dogmatized.

To me, such claims are immoral. Any claim to finality, whether
it be from the left (e.g., atheism, doctrinaire communism) or
right (e.g., religious fundamentalism, doctrinaire free-market
economy, fascist capitalism) is immoral.

By morality, I mean that which enhances relationship. By
immorality, I mean that which supports separation. This is
in distinction to traditional definitions that defined certain
behaviors, in and of themselves, as moral or immoral. What
to wear, what to eat, how to behave on holy days, and the
hierarchy of authority ("*Wives, obey your husbands*") are
examples of these.

Overpopulation, encouraged by religious dogmas against contraception rather than choice, is a contemporary tragedy emanating from a blind following of dogmatic leadership. So are many wars, oppressive regimes, and assertions of human mastery over vast expanses of the earth. Religions must give up claims to supernatural uniqueness and reestablish their spiritual roots in human experience and history. Supernatural claims change one's religion from a broad binding together of the planetary (indeed, universal) community to a narrow binding together of only those who will follow the leader who claims such certainty.

When anyone tries to formulate what life or truth or personhood is, that formulation must take the mortal form of words. Formulations must not be confused with reality. They are passing ways to make sense out of present experience. Religions are founded when someone institutionalizes one of those passing ways. Worshiping doctrines or formulations as if they were the final truth is idolatry. Words are finite. They can be interpreted in many ways. Anyone who claims to have the only true interpretation is claiming to know more than humans can know.

Are there no values to which we can give ourselves except those interjected supernaturally from outside the planet? Are there no planetary values? Are we valueless—of no value, of no values—if we are not supernaturally endowed?

Billions still follow traditions based on a claim to supernatural exclusivity and certainty. Not all are mere sheep-like literalists; there are many who see such traditions as nothing more than traditions—and are willing to join with people of other traditions, or of none, to share experiences and seek common ground. Many more seek to plumb the deeper truths of their faiths to tap their power for the establishment of the social and

ecological justice that can enhance life on earth. But millions of others have lost all faith in those traditions and have not yet discovered a new morality that can relate their inner aspirations to their perceptions of reality. The search for such a morality prompted these essays and it seems to be a venture that could be shared in by all.

Many humans appear prone to polar thinking: Tradition or no tradition. Belief or no belief. Black or white. What lies between the poles?

Imaginative faith

Richard Bach, in his book *Illusions*,[2] substitutes the word "imagination" for "faith." It is an excellent substitution. The very word "faith" was originally a verb meaning "to act on" something. At times, authoritarian church leaders have called for followers to have faith in dogma and not to be confused by historians who may uncover facts contrary to church doctrine. Citizens of police states know painfully well where such thinking can lead.

To quote Howard Thurman: "Religious experience is fluid, dynamic, yeasty: all of these. But the mind can't handle that so it has to imprison it in some way—bottle it up—and then extract concepts, dogmas, so the mind can make sense of it. But religious experience goes on and therefore dogma is always out of date."

Dogma and faith are intertwined in political and religious fundamentalism. The Christian New Testament adage "the truth will set you free" is interpreted by fundamentalists to mean "the dogma will set you free." Truth, via historical study or literary criticism, is thus seen as the enemy.

14

Bach's use of imagination captures the meaning many non-fundamentalists have attempted to convey when they have written about dynamic faith.

What do you imagine can be?

*What values do you image for yourself, your family,
organization, community, planet?*

*What do you imagine for the environment,
the disenfranchised, hungry, and sick?*

*Take the leap
from your imagining to your daily choices
and you will have committed yourself,*

*not in reference
to a blind acceptance or rejection of "revealed truth,"*

*but in reference
to your core being.*

Essay 3
A Journey Without A Map

The artistic journey of Paul Cezanne exemplifies a deep search for new values. Art in nineteenth-century France was captured by realism. The style was to produce exact likenesses of people and scenes. Realism served to support the function of the state and the church. Most subjects were from the highest rungs on the hierarchy of power: royalty, religious symbols, the wealthy.

A number of artists bucked that tradition. They painted a more common world and they painted their personal impressions of reality. They focused on color and light, daring to break the norms established by the realist school. Known as Impressionists, these artists—including Cezanne as a young man—were often in trouble. They were viewed as radicals and revolutionaries who, because they challenged the status quo of art, also threatened the status quo of politics and religion. Actually, most were apolitical, but those in power did not differentiate. The usual channels of art-exhibiting in galleries, receiving public acclaim, appointments to teaching positions, awards of subsidies -were usually denied them. Similar artists were expressing themselves at the same time in many cultures through canvas, sculpture, music, poetry, and literature—an amazing world phenomenon.

In time, Cezanne found that he didn't quite fit this niche either. He said, in essence, "This way isn't for me. I'm not satisfied with Impressionism; there's no lasting form and order there. But I won't go back to the traditional. I want to find lasting form and order in the midst of color and light."

Cezanne struck out in a new direction—one now described as Post-Impressionist: not Realist, yet not Impressionist.

16

He wanted to find lasting order in art, and that was how he painted in his later years. Picasso, among others, built upon the foundation that Cezanne had dared to lay down. In 1989, I saw Cezanne's paintings of Mont Sainte-Victoire from 1885 and 1905 side-by-side in Moscow's Pushkin Museum. The difference was striking! The latter picture reflected an architectural structure not found in the more pastoral earlier work.

In terms of values, I am also on a journey much like that of Cezanne. I won't return to traditional morality. The old absolutes—built on a hierarchy of male power—don't fit my world anymore.

Perhaps once we knew what it meant, for example, to honor our parents. But now many ask what honor means. How do people honor parents who abuse them? We're just learning how pervasive child-abuse is in the world . And that abuse may be prenatal. A recent report indicated that 30 percent of the children born in a Pennsylvania hospital were cocaine addicted. Fetal-alcohol syndrome is affecting more and more children.

Traditional morality served a culture vastly different from ours today. Prohibitions against premarital sex for women originated in a culture which viewed women as property to be owned; used property was less valuable when it came time for a marriage contract. Today we might make the same choices of honoring parents or valuing chastity (but surely not for women only), although not simply because someone tells us to do so. And, like Cezanne, we can reject the latest new-school reaction to traditionalism. We need not accept the notion that all values are irrelevant or that we should do as we feel. Permissiveness and nihilism are not the only alternatives to traditional morality.

We can nurture our own emotional, physical, and spiritual health by giving priority to values exploration. This means we pursue a sorting-out process free of, or regardless of, the guilt that says we have abandoned the right and true. Very simply, we must allow ourselves to determine the values that help us meet our deepest needs as individuals and as communities sharing the same planet with other living things. This takes courage. It is a journey that appears to be without a map, but world myths and traditions can enlighten us. Our roots can be rediscovered and enrich us more than the literalism of our childhood way of thinking. And communities of people who are on such a search abound, some for centuries. There is much to learn from each other.

Many voices compete for our attention. To integrate and internalize values worth living for, we must differentiate between what we have been told we should want and what we will choose. We must learn to say yes when we mean yes and to say no when we mean no. We must let go of old dreams and grab hold of new ones.

In short, we assume a deeper sense of responsibility for ourselves and who or what we are becoming. To claim our full measure of responsibility, we make our choices on the basis of knowledge, not habit.

> *We achieve informed personal choice*
> *by becoming aware of our alternatives.*

We face serious hazards when we focus our energy on values explorations. Perhaps the most insidious enemy of values exploration is the human tendency to turn a way of thinking into **the** way of thinking. Without realizing it, we allow our new opinion to become our new dogma.

Dogma in the guise of open exploration is just as destructive of human freedom as dogma clearly advertised as dogma. We need to learn to recognize the roots, sources, and values biases of whatever systems we use to make sense of life. For example, we should know that empiricism can give primacy to science as the final truth.

Are we open to inquiry, or closed? This is tricky. An authoritarian atheist is as dogmatic as a religious fundamentalist. And between those extremes there is the danger of nihilism (i.e., "Since I do not know for sure, nothing matters").

The journey to find new meanings is not unlike the later stages of the adolescent transition from childhood to adulthood. When I was a child I looked to authorities for the answers to the riddles of my existence. As an early adolescent, I may have retained my dependency by accepting whatever I was told. Or, I may have reacted with counter-dependency and rejected all parental admonitions.

To be adult is to take responsibility for one's life, to co-create with others core values or moralities as the central foundations upon which we can stand. To achieve that adult task, one may find kernels of truth in childhood learnings. (There may not be a literal St. Nicholas, but there are important truths of love and hope in the St. Nicholas myth.)

> For me, the essence of being grounded
> is to take responsibility for one's core values.

Essay 4
Core Moralities or Values

Is it possible to find direction when it is not given from above? Will it not be idiosyncratic, situational, blowing with the wind?

On a shrinking planet, the various claims to final truth are confrontational. They emphasize not our commonality but our differences. They feature a win-lose, right-wrong style. Each developed out of a particular situation at a particular moment in history.

The various fundamentalisms are situational, as their teachings are more the result of history and geography than of revelation. They give the appearance of finality and security, but it is they who leave us, as a global village, without direction. It is an illusion to think otherwise. The paradox is that the fundamentalists believe that they are giving us a direction while, really, they give us countless, competing systems.

I believe that as people mature in the task of defining core moralities, there will emerge a core commonality across the planet derived from our common humanity and shared ecological, economic, and political dilemmas. For the first time, morality will be able to summon the strength of universal motivation, "sourced" by the internal spring to which we all have access, and united in a holism that is respectful of individual and cultural differences. It will belong to us, not to the priests, the religious institutions, or the supernatural gods!

Ross Snyder

Ross Snyder, whom I introduced in the preface to this volume and who did the original work in defining core moralities, asked this question:

"What is the minimal core of morality absolutely necessary for personal life and productive civilization?"

'What goes into the making of a free and significant person?" Snyder also asks. "For morality is not commands and laws added on to love, but an actualizing of what we were meant to be. It is our existence. Morality is also the path along which we can advance.

"That we never all come to the same statement of the basic moralities is not defeat. It is important that we find areas of agreement, and that each of us get our words and actions into some close conversations with each other. For the gulf between what society says and the principles on which it actually operates in this world results in our powerlessness and our sons' and daughters' confusion. If we can find what our 'spine' of morality really is, then all else is possible. If we are kidding ourselves as to what we are, we have nothing to start with."[3]

What is a core morality?

It is a call to meaningful living, a way to be, rather than a list of prohibitions or admonitions. As such, it is forever dynamic, enticing each of us to discover deeper and deeper layers of meaning. Thus, it leads us to new myths which help to harmonize our purposes and behaviors.

I notice my hesitancy to write further. The very act of listing

these attributes of core moralities has its frightening side for me. I recall vividly a certain youth who had been raised a strict Catholic. In 1970, I had come to know him as a true-believer hippie celebrating his religious rites with drugs and preaching the virtues thereof. Then I knew him as a fundamentalist Christian. He believed that he had changed in these three manifestations, but nothing basic had changed. The dependent child seeking a true belief had simply changed hats. My fear is that this same man would accept the core moralities as a new dogma rather than as the challenges they are. The drive to know-for-sure-what-I-know is still overwhelming to many.

Going beyond that fear, I offer these core principles that have special meaning for me as I make sense of my existence. Readers will add and subtract what makes sense for them.

The Core Morality of Graceful Aging

When a three-year-old looks at an eight-year-old, she sees a bigger, older person. At eight years one can hardly imagine eighteen, and so it goes. All are aging. All are aged to those younger.

Many cultures venerate youth . This is crazy, because all of the venerators are getting older. Even idolized youth are getting older. Isn't it ridiculous to venerate that which nobody is becoming? Isn't it much more sensible to venerate becoming older? To place supreme value on youth is life-denying, for it implies that we are better at the beginning of life than at the end, and it thus negates any possibility of gaining wisdom along life's path.

Many have a tragic view of the aging process . Many have accepted the idea that the aging process is a matter of having less fun, reduced sexual pleasure, and becoming narrower

in thinking. As a result, many people choose to fulfill such unhappy prophecies, although none of them is a necessary consequence of aging. They have decided to believe that such tribulations are inevitable. In contrast to this insanity, I propose that we live life in such a way that those younger than we are will say, "How wonderful it must be to be that age."

It is obviously true that aged persons have a higher susceptibility to some diseases than younger persons. And, of course, it is in old age that anyone who has lived a healthy, fulfilling life will die. But, these truisms apart, one's well-being has less to do with age than with such things as: How healthy is your body? How do you feel about your appearance? Do you like yourself? Do you project openness to others? How does your view of life get communicated to others? Are you optimistic, spirited, curious, risk-taking, playful? These characteristics we admire can be manifested at any age. And how genuine is your sense of humor? How willing are you to learn?

There are many ways to resist what might be called the conspiracy against learning how to grow older in our culture. Study worn-out, older people and consciously decide not to be like them. (Most have a way of acting as if they were losing their value, wearing out, dying.) That kind of aging is a role which is learned. That role is not only imposed by many forces in our culture, it is also self-imposed. Such people seem to think, "I'm old so I have to act old, think old." In contrast, the key to good mental and physical health is the ability to remain alert. How joyous it is to meet the many elderly people who have faced the vicissitudes of the aging process but have remained fully alive.

So each of us, regardless of age, should ask: *What message am I giving the world about growing older?* If you're 23, what message are you sending 13-year-olds and 8-year-olds?

Ross Snyder

If you're 47, what is your life saying about aging?

Do younger persons rejoice that you are so alive, whatever your age? Graceful aging is a way of venerating being alive, of seeing purpose in the whole of life -and saying no to the stereotypes that lead to senility and early death.

I cringe when I hear someone tell a teenager, "Enjoy it, the teens are the best years." I feel sad for the speaker. Those beyond their teens have had many more years to experience the joy of being. All of us are getting older. Why not look forward to it? Why not create the future we want rather than lament that we are not what we used to be? "Do not let death find you already a corpse. Let him find you in full dance," says the sage.

The Core Morality of Striving for Authenticity

Ross Snyder listed this core morality first. Notice that it is not a morality of authenticity, but rather one of *striving* for authenticity. It is not a mountaintop we someday reach: It is a journey.

Snyder did his writing in the context of adults coming clean with youth. It focuses the phoniness in the older ones when they pretend to know more than they know, be who they are not, or deny the errors and inadequacies that are part of being human, younger or older.

Being authentic is knowing what you care about and standing up for that. It is being in touch with and "owning" your emotional states: fear, hope, joy, anger, love, hate, whatever. It is being aware of your defensiveness and acknowledging it and choosing to defend or not defend. It is to accept either *not knowing* and feelings of inadequacy or *knowing* and feelings

of confidence and success.

Think for a moment about someone dear to you. Get this person clearly in mind. Now, think, how much does that person know about your fears, your hurts, your pain? How much does that person know about your sense of inadequacy? How well does that person know the real you? Would that person be surprised to know that when asked to focus on someone special while reading this you picked him /her? Does that person know how central s/he is for you? Does that person know about your concerns, especially in relation to that person's life and welfare? If you fear that s/he will go away, does that person know about that fear? If your answer is "no" to these questions, then your authentic self is not known to this person.

Most readers of this book in their fifties or older grew up in an age when politeness, thinking of the other, was the norm. They were told, "Don't hurt anybody." However, few mentioned that if you make that your life's cornerstone, you will never experience the depth of love. Pain and joy are partners just as love and hate are forever joined. Both exist together. They are not opposites. When hate and pain are treated as if they were the enemy of love and joy, there is no relationship -only indifference and apathy.

The older we are, the likelier we are to have been taught that to be a good person one must put the other person ahead of oneself. The ideal was to put oneself last. We justified that posture with admonitions about the virtue of being "meek." Apparently,we have shifted from the original meaning of this Greek word (*praus*). In its origin, to be meek implies wholeness and integrity. A related meaning is knowing who you are or not thinking of yourself as better or worse than you are. A hungry baby who cries is meek. Jesus, overturning

tables and cleansing the temple (Christian *New Testament*), was being meek, whole, and acting with integrity from his perspective. You, when you're proud of your actions and are sharing this fact with significant people in your life, may be meek. That is, you may be sharing with wholeness and integrity.

Ruth Emory, a student of Snyder, has written: "The authentic individual will not pretend to stand on ground which is not in reality his/her ground....This is really you, and not a 'put-on' person. Authentic life means that people can feel able to trust you because they know you mean what you say and really are as you seem. There is an assurance that even though they may hate what you are and stand for, they can depend on it. You are no will-o'-the-wisp."

She shared ways this core morality may be expressed:

"Individuals are fully aware of their possibilities as well as their limitations, and do not deny them."

"They are able to say that they do not know something and not be frightened by the necessity for such acknowledgement."

"They invite a critical scrutiny of their ideas and really welcome what comes without either supinely acquiescing or loudly defending."

"They expect others to be authentic and they help them discover who they are and where they live, and are sensitive to—but not 'thrown' by—their inconsistencies as they find their personhood."

"They are open and able to receive messages about themselves without becoming unduly hostile or resentful."

"They speak to others in the group honestly, from a wholeness of spirit."

"They give their whole being to a group, come with all they are-and do not hold anything back since it is important to be as honest as possible."

"They say what they truly believe to be the case insofar as they can see it, and not what they think they are expected to say, but they also speak responsibly, not out of whim or smallness of spirit."[4]

Such authenticity begins with self-differentiation. Before I can be authentic, of course, I must know who I am; I must distinguish between me and my history, my judgments, my projections, and the external world. I must accept that experience is not external to self, but continuously created within.[5] Only then will I speak for myself and not believe that what I am experiencing is what all are or should be experiencing. My reality is not your reality. With such clarity I may avoid believing that my feelings are "our" feelings, my thoughts "our" thoughts, my perceptions "our" perceptions, my reality "our" reality! Authentic behavior is grounded in such differentiation.

Howard Thurman put it this way: "There is something in every one of you that waits and listens for the sound of the genuine in yourself. It is the only true guide you will ever have. And if you cannot hear it, you will all of your life spend your days on the ends of strings that someone else pulls."

Striving for authenticity reduces the pretending, game-playing way of being in the world. It opens the door for intimacy in relationships, for integrity in the marketplace, and for openness among people of differing backgrounds.

The Core Morality of Midwifery

Another dimension of relationship is to "be" in such a way as to assist others in their birthing of ideas, plans for actions, dreams, self definitions, and core moralities.

Snyder applied the word "midwifery" to such assisting. Ruth Emory describes it this way: "To midwife means to assist at birth. To assist is really all that can be done: to help this idea come forth; to encourage a person to take that position; to help someone find courage to come to terms with him/ herself. . . . Also. . . . midwifery does not dictate the outcome. It helps what is there to be born. . . . Midwifery means . . . not . . . trying to dictate the results of the birthing process. [This also means] to offer a bulwark of strength and support and a safe place of refuge during the working out of feelings and while frail images are being examined and understood."[6]

It is surely clear to any midwife assisting in the birth of a newborn that the child is not hers. It is not so clear in the kind of midwifery to which I am referring. In those areas about which we feel passionate, an inherent tension exists between the desire to midwife, and the desire to dictate the results. The growing edge in this core morality is the struggle between those poles.

The Core Morality of Commitment

Commitment is the glue which holds together all other core moralities and, more importantly, holds together humans, the social fabric, and the web of life that encompasses all life forms.

Commitment, not methods, is what drives humans. My commitment to a certain core morality is the spark and the

Ruth Emory

flame. Methods and strategies may fail but, if committed, I continue toward my vision.

Four major areas for commitments are:

1 Commitment to Relationships

Intimacy, trust, and openness with others require that my commitment to them transcend the particular feelings which I may have at the moment. (For instance, if I am angry, this does not mean my commitment will end.) The message "You can count on me" means I am committed to caring for someone— regardless of my own troubles. Parents increasingly fail to make that kind of commitment to their children. They don't say, "We will be here for you through your growing-up years." (One study in Seattle indicated that 40 percent of homeless teens are homosexual or bisexual. American society pays a heavy price for homophobia and the parental rejection of youth because of their sexual orientation.)

"To be a parent," says Snyder, "means to be a faithful friend of the growth of a son or daughter -come hell or high water."[7] Nowhere is this need for commitment more vivid than in partner relationships.

> *I want a partner*
> *with whom I can dance*
> *who does not ask of me or us*
> *or life*
> *too much of what it cannot bring.*

What life cannot bring is constant romance. Much of recent Western culture has given primacy to feelings of romance (often called "falling in love") in choosing partners. Romance as illustrated in the stories of Romeo and Juliet, Tristan and

Isolde, and Abelard and Heloise is maintained by a lack of sexual or marital fulfillment. Romance is "falling in love" with an idealized image of the other.

We project onto the loved one that which we want to find.

On the other hand, deep partnership is a bonding requiring profound commitment and risk, an empathic knowing of the other. At its core, it is sustained by choice, not feelings. Bonding love is a choice to journey together, transcending feelings of love and hate, romance or disdain. Feelings will come and go. Romance will come and go. Emotionality cannot be the primary criterion by which the success of bonding is measured. Deep partnership is grounded in commitment.

2 Commitment to Community

As marriages fail and families splinter, we hear more and more about the need for support groups, and for good reason. We all need to live out our lives at least striving to help build communities of significance. Over the centuries, many religious people have hoped that their religious institution was such a community. On occasion it has been and, often, it has not been. In our times, common-interest groups such as gays, Blacks, women, senior citizens, parents without partners, and teens have actively developed support communities.

For support communities to avoid narrowness, there must be a diversity not often found today. A teen, experiencing the pits of life, may find a sixty-year-old who knows how to be a friend. It is absurd to segregate people by age or any other characteristic. Married and single people need to learn how to be together. Men and women need to be together. Gays and straights and teens and elders need to be together. And support communities need to reflect the rich ethnic diversity of planet

earth. Indeed, it is in such communities that the search for values is most likely to be fruitful.

Where is community in your life? How are you striving to find that community? What have you done, over a period of time, to create or nurture community?

3 *Commitment to Justice*

> *"First the Nazis came...*
> *First they came for the communists, and I did not*
> ***speak out**—because I was not a communist;*
> *then they came for the socialists, and I did not*
> ***speak out**—because I was not a socialist;*
> *then they came for the trade unionists, and I did not*
> ***speak out**—because I was not a trade unionist;*
> *then they came for the Jews, and I did not*
> ***speak out**—because I was not a Jew;*
> *then they came for me—and there was no one left to*
> ***speak out** for me."[7]*

"Justice, on the inside of us, is our willingness to become involved when some other person's right to life and growth is being violated. To fight only when our own existence is constricted or threatened is not yet a mature morality.

"Underlying this willingness to stand with others against the oppressor is a feeling that we are all in this together; 'we are members one of another.' And when fundamental rights are denied to any person, by just so much are the structures of human dignity and inclusiveness weakened for all of us."[8]

> *Could be in the vast scheme of things*
> *When all is said and done*
> *That I am you, and you are me*
> *And each is everyone.*

33

4 *Commitment to the Planet*

As I write, the green movement is ascending as a planetary force. Surely no one has stated commitment to the land more eloquently than Chief Sealth, for whom Seattle is named. In a letter he wrote to President Franklin Pierce in 1855, the Chief expressed his puzzlement about the strange idea of buying land. To him, the earth appeared to be the white man's enemy rather than his brother or sister. In his famous 1854 speech, Chief Sealth said:

> *"There was a time*
> *when our people covered the land*
> *as the waves of a wind-ruffled sea*
> *covered its shell-paved floor,*
> *but that time long since passed*
> *away with the greatness of tribes*
> *that are now but a mournful memory. . . ."*

"Our dead never forget the beautiful world that gave them being. They still love its verdant valleys, its murmuring rivers, its magnificent mountains, sequestered vales and verdant-lined lakes and bays, and ever yearn in tender, fond affection over the lonely-hearted living, and of ten return from the Happy Hunting Ground to visit, guide, console and comfort them. . . .

"Every part of this soil is sacred, in the estimation of my people. Every hillside, every valley, every plain and grove, has been hallowed by some sad or happy event in days long vanished. Even the rocks, which seem to be dumb and dead as they swelter in the sun along the silent shore, thrill with memories of stirring events connected with the lives of my people, and the very dust upon which you now stand responds more lovingly to their footsteps than to yours, because it is rich with the blood of our ancestors and our bare feet are conscious

of the sympathetic touch. Our departed braves, fond mothers, glad, happy-hearted maidens, and even our little children who lived here and rejoiced here for a brief season, still love these somber solitudes and at eventide they greet shadowy returning spirits. And when the last Red Man shall have perished, and the memory of my tribe shall have become a myth among the White Men, these shores will swarm with the invisible dead of my tribe, and when your children's children think themselves alone in the field, the store, the shop, upon the highway, or in the silence of the pathless woods, they will not be alone. In all the earth there is no place dedicated to solitude. At night when the streets of your cities and villages are silent and you think them deserted, they will throng with the returning hosts that once filled them and still love this beautiful land. . . ."[9]

The morality of commitment is the structure of life—even though it makes life tough at times. It enables and accompanies the morality of authenticity. Inevitably, life brings us to face:

"What authority do I recognize other than 'I want?'
Whom do I serve other than myself?
What future am I helping to bring off?"[10]

Commitment is risk-taking. It is not about being sure. It is about taking a stand. It is about making choices in a non-black-and-white world, where the final answer is rarely known for sure. It is about having the courage to be wrong, the courage to fail.

It is about making choices to establish one's direction rather than being dictated to by vacillating emotions or by an authoritarian leader or an inspired book interpreted by authoritarian leaders.

The Core Morality of Being My Word

When words and action do not match, which is believed? If my words say "Thank you" in a sarcastic tone, which is believed?

In the evolution of the species, we observed the natural order and related with each other and the natural order before we had language. Language is the external expression of inward sensing, intuiting, knowing. How desperately we grasp for words to say what resides in our deepest selves and what, profoundly, cannot be said. That grasping is highlighted when we try to communicate with someone who speaks a language foreign to our own.

All language is interpretation; therefore, all creeds are interpretations. All myths, in their imaginative mystery, are interpretations. All poetry and prose, all historic embellishments and all revelations, are interpretive. How exciting is the pursuit of their essence! A core morality for the individual is to find those *words most congruent with one's own being* and to know that one's words are always being interpreted.

What does it mean to give one's word? We create with our word. Some ancients believed that the world was created with a word spoken. To be one's word is to be congruent. It is as if I am announcing to others: "You can count on me. My word is not idle. What I say I am creating. What I say is my being." 'The truth consists not in knowing the truth but in being the truth,' wrote Danish existentialist Kierkegaard.

<u>Look for consistency between what I say and what I do</u>. Tell me when you perceive those inconsistencies which will be there. Because language is interpretive, there will often be a

36

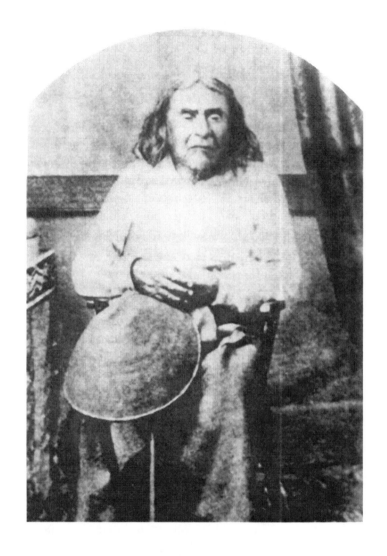

Chief Sealth

(photograph by L.D. Lindsey)

gap between what I mean and what you think I mean. Your feedback to me about that perceived gap is critical to us if we are to grow in our relationship.

Language creates reality. When a female refers to herself as a *girl*, she is creating within herself and her environment a way of being vastly different than when she says *woman* in referring to herself and other females. When organization leaders use the language of "men and girls" rather than "men and women" they are creating a different reality about how people will interact, and about the career possibilities available. Also, **I am my word about commitment**. If my words are:

Probably	*Hopefully*	*If I can*
I'll try	*It wasn't my fault*	*Nobody told me*

then I create a likelihood of not achieving, of blaming, and of finding excuses. If my words are:

I'll handle that	*You can count on me,*
I'll complete it by (when)	*I'll make sure I'm notified*

then I create the likelihood of dependability and responsibility. I face the world as one whose word is truth.

The core moralities of "being your word" and "striving for authenticity" are twin sisters for me.

Essay 5
Beacons for the Future

It is my intention that these essays serve as a catalyst tilting toward the new creation that I believe will flourish on the planet when enough people understand that we are the creators of our morality and that past creations are no longer sufficient.

The movement from tribes and city-states to nations has been painful and bloody. Wars and rumors of wars have abounded in the twentieth century as this evolution continues. This world is now taking shape along economic alignments. Nations now depend on other nations, recently viewed as enemies.

The next move is to a planetary consciousness. Nationalism has provided a measure of security and identity but is no longer a viable myth on a shrinking planet. My new myth is a planet earth supporting cultural diversity as well as economic, human, and environmental interdependence.

All that we have is what we have in this moment, and that is cause for celebration. The past is what we conjure up as a memory in this moment. It is past; it does not exist. The future is our image of how things may be. But the future cannot really exist until it comes into being.

> *There is now.*
> *To be here—present —alive*
> *NOW*
> *is to have it all.*

It is in this *now* that we must set to work to create a future in which humankind will thrive along with other life forms as loyal children of the Earth family.

Ross Snyder put forth an action proposal in his speech in 1959, from which I have been quoting. Perhaps its time has come.

"There is need for what Erik Erikson calls 'adult guarantors' - significant adults whose integrity and power are enough that when they recognize a young person, she/ he feels assured that certain ways of life represented by these adults have a future. And she/ he is confirmed.

"The action proposal I make then is the development of such adult guarantors in our communities. We should try out inviting a small group of ten or twelve people to come together for a few sessions and do their 'homework' on the core moralities out of which—however imperfectly—they live.

This discussion cannot just be a reiteration of the authority of the Ten Commandments. I am not against any of the Ten Commandments, and I am happy to live in a society which still finds its grounding in them. But I think we have to ask for some new formulations that take account of values on which young people particularly expect us to 'come clean' or they regard us as phonies.

"Now while I have suggested that we begin with a sort of experimental group, this same kind of consideration—only expanded and deepened—is an essential part of the training of public school teachers. It should not be left in their training to a session or two of general discussion; for the central core of all education is the question 'What is personal existence?' And the quality of the teacher's culture is, finally, her worth as a teacher. Perhaps—in some Utopia—people will not become parents until they have gone through such a combination of hard thinking and getting themselves all put together.

"The public's stake in training for moral leadership, therefore, begins at this point - with developing resources on core morality in adults and in helping them to [be centered]. We have not done very much thinking about morality for some time except to moan about its decline. And we have done more dispersing and disintegrating than focusing to a core.

"Now let us talk about what we might do with young people. For today we have some of the most capable young people whom the world has ever seen, and they are often more creative than grown-ups.

"First let us strengthen the resources of the youngsters making the good try. We often think that only the delinquent should give consideration to moralities. But my own impression is that on many matters of youth life, it is the young people themselves who most effectively can give moral leadership; they share the common fate of being young, and of being potential life partners for each other."[11]

To be someone of worth and importance, to be who we really are—unique, accepted, and accepting—means resisting being just a pawn, resisting being pushed around. But this quality of centered-ness is not something we can appropriate just by snapping our fingers or reading a book. It requires having a self-conscious knowledge of how we get our values, how we hold our values, and how the present situation is unique in the historical development of values.

This knowing begins by seeing ourselves living in an exciting period of history when the new is emerging and we are co-creators of the *not-yet*. We have the challenging opportunity to join in the exciting work of forging ethics adequate to these times, ethics that merge individual fulfillment and social responsibility.

41

The nature of humankind is not fixed in concrete. Our nature is changing as our opportunities and troubles are changing. Many, of course, find this idea highly offensive. For them, moral principles were given to us in the distant past—once and for always. People are perceived as unchanging, non-evolving creatures.

My view is we are at a new juncture in human history. We have been called to be pioneers in the shaping of values for the rest of our lives. We can have a compass, as these preceding pages have indicated.

As I wrote in March 1991, democracy is struggling to ascend in much of the world . But democracy continually needs redefinition. *It is guided by dynamic core moralities* .

American democracy in the eighteenth century was for the white, property-owning males. It has taken two centuries of confrontation to include women and ethnic groups in the laws that govern U.S. democracy. The practice of that democracy still lags badly. Discrimination, with its economic consequences, still abounds in America and around the world; the gap between the rich and the poor has increased in the last decade. Chief Sealth (Seattle) would weep over the plundered earth, just as the people of Iraq and Kuwait now weep over the loss of tens of thousands of loved ones and of their homes and workplaces. Suffering abounds across the planet and people still reach for authoritarian answers.

> Without exploration and dialogue,
> which is inherent in democracy,
> that process cannot flourish.

The process of building and rebuilding core moralities is dynamic and must be renewed in each generation. It will

be greatly enriched as people with different traditions come together to unravel the animosities communicated from the age of certainty when their ancestors held their myths as literal and denounced others as enemy, pagan, infidel.

> *Then we will mine*
> *the riches of our various traditions*
> *and raise up core values*
> *as beacons to our future.*

Notes

1. Howard Thurman, mystic, poet, cleric, was once pastor of the Church of All Nations in San Francisco. Thurman has been called the Godfather of the Civil Rights Movement. He was the chaplain at Boston University when Martin Luther King, Jr. was completing his doctoral degree and was an influence on MLK's life. Thurman was a powerful presence on the campus. As a student, this author heard this quote in a sermon by Dr. Thurman at the Boston University Chapel.

2. Richard Bach, *Illusions -The Adventures of a Reluctant Messiah* (New York: Doubleday, 1977).

3. Ross Snyder, "Core Moralities on Which Adults Must Come Clean With Youth," mimeographed (1959). Reprinted with the author's permission.

4. Ruth Emory, "A Point of View for Participating in a Ministry With Youth," mimeographed (1960). Reprinted with the author's permission.

5. I am deeply indebted to my close friend and colleague, Ron Short, Ph.D., for his work on differentiation and for his emphasis on "experience as continuously created within." He has published materials and developed a training methodology to "teach" differentiation. I do not believe leaders can fully realize their potential without such understanding and skill.

6. Emory, "A Point of View."

7. Martin Niemoller (1892-1984), German Protestant pastor, social activist and Nazi prisoner in a concentration camp. from Wikiquote.

8. Snyder, *Core Moralities*

9. *Ibid*

10. This speech was addressed to Territorial Governor and Indian Commissioner Isaac I. Stevens. It was apparently first published in the *Seattle Sunday Star* for October 29, 1887, based on notes taken by Dr. Henry A. Smith, who was present at the speech.

11. Snyder, *Core Moralities*

12. *Ibid*

Study Guide

Living with Purpose When the Gods Are Gone

This book of essays deals with two dimensions:

1) How we know what we know? and
2) examples of core positions or moralities.

The intent of the book is twofold:

1) To free humans from the tendency to look outside
 themselves for answers, while still valuing
 the wisdom of various traditions and other people.

 Truth is within ourselves; it takes no rise
 From outward things, whate'er you may believe.
 There is an inmost center in us all,
 Where truth abides in fullness
 - Robert Browning

This first intent is that humans will be empowered to tap
the sources within themselves—and indeed, to get it clear
that *such sources are likely one's only final authorities.*

2) Empowered and excited by the acceptance of
 one's own authority, to encourage humans to gather
 with others to clarify values and to strategize
 ways to enhance the lives of all on planet Earth.

This guide may be useful to an individual working alone, but it has been designed for group work. Group process suggestions appear on the left side; substantive questions, the right.

Leader: Welcome people and state that the objective is a *sharing process*, with all having the opportunity to contribute. Toward this end there will be both large-group and small-group discussions.

Form trios. To do this, please circulate and be with persons with whom you usually have little chance to talk.

In your trios, discuss
1. why you are here
2. what you intend to get from this (these) discussion(s)

Total group: Hear highlights of small group discussions.

NOTE TO GROUP LEADER

Some members may want whole group work all of the time, with no trios or small groups. This will work if the group has only six to ten members, as long as someone monitors participation. Of course, the larger the group, the more difficult it becomes for everyone to participate. Usually those who oppose small-group work are the ones who talk the most. Using structures (i.e., pairs, trios) that increase everyone's possibility of participating is congruent with the core moralities in Essay Four, the experiencing of which should be an important part of the discussion.

Trio: Focus on
1) What strikes me?
2) What excites me?
3) What troubles me?
4) What puzzles me?
 or you can follow this
 more detailed guide:

1) In the first paragraph
 the author says: "With
 the decline of faith in
 supernatural gods and
 goddesses, we stand at the
 edge of an amazing time
 of hope!"

 Could the word "despair"
 be substituted for "hope"?

 Would you write that
 sentence differently?

2) The author describes his
 growing up and the "true
 belief" tension in his
 family. What's your story?

3) On page 3, the author
 says: "Such a journey,
 in concert with others, is
 imperative today." What
 do you agree or disagree
 with in this statement and
 the paragraph in which it
 rests?

4) Read the poem. Rate how it impacts you on a 1–10 scale (10 = highly impactful). Share your number and tell why.

5) Later, in the fourth essay, the author describes the morality of *midwifery*: helping others in the birthing of ideas. Are you giving and receiving that now in this trio? If yes, be specific about the "birthing" behaviors. If no, also be specific about behaviors and ask for what you want in subsequent trio conversations. (Your answer is probably a yes <u>and</u> no rather than a yes <u>or</u> no.)

Total Group: Hear highlights from each group. List the common themes that emerge. Encourage a total group dialogue while at the same time vigorously supporting each persons right to dissent. If there are fundamentalists present, midwife them, paraphrase them rather than arguing. Let them come to understand that this is a safe place to be and that it is OK to differ. Of course, expect them to listen to others as well.

Trio: Focus on:
1) What strikes me?
2) What excites me?
3) What troubles me?
4) What puzzles me?
 and/or:

1) On page 6, a paragraph begins: "As language developed and stories were told, the origin of the stories was lost." Here the author describes the evolution of nomadic stories into literal belief systems. If you agree, then why is this point of view not easily promulgated? If you disagree, say more.

2) On page 6, the author mentions two ages. If you were the author, how would *you* describe these distinctions?

3) On pages 7-9, trace the story of the god "in whom we trust." Rate your response to this on a 1–10 scale (*10* being: "Yes! Yes!" and *1* being "The author is way off"). Share your number and discuss.

4) On page 10, a paragraph begins: "The ancient myths..." Read this paragraph and discuss your understanding of myth.

5) In the later fourth essay, core moralities of *commitment* and *midwifery* are described. Without reading ahead, test your commitments to this learning trio and whole group. What about midwifery? Are you assisting each other in the birthing of ideas?

Total Group: Hear highlights from each group. List common themes. Encourage total group dialogue while vigorously supporting the right to dissent.

You may choose to reconstitute trios both to encourage new dialogue relationships and because Essay 2 deals in a different way with the primary focus of Essay 1: that is, How do we know what we know?

Trio: Focus on the usual "What . . . ?" questions

and/or:

1) On page 12, the author uses the word *attack*. Has he stepped across his own boundary and become dogmatic and a "true believer" himself? Where is the line that divides conviction from true belief?

2) The author defines morality and immorality in a "process" sense rather than as "acts." Discuss how you like this definition and what concerns you have about it.

3) The author claims that the substitution of imagination for faith is "excellent." Is it for you?

4) In the later fourth essay the core morality of authenticity is described. Without reading ahead, but rather as you now understand authenticity, is your trio and is the total group being authentic in these discussions, or is *group-think* taking over? That is, are there some ideas that are not OK to mention here?

Total Group Discussion

53

Trio: Focus on the usual "What . . . ?" questions and/or:

1) Read the paragraph beginning: "In time, Cezanne..." How does his journey match your own?

2) On page 17, a paragraph begins: "Traditional morality served a culture vastly different from ours..." Discuss.

3) The paragraph on page 19, beginning with the word "Dogma," expands *dogma* to areas not commonly associated with that word. What about you? Which dogmas have attracted you in the past, or do so now?

4) Read the last sentence of this essay. Does anything keep you from taking responsibility for your values?

5) Are you experiencing the kind of *authenticity, midwifery,* and *commitment* in the trio or learning community that you want? If not, how will you make a change? Or do you see yourself as powerless here?

Total Group Discussion

ESSAY 4: CORE MORALITIES OR VALUES

1) In the third paragraph, the author makes what some would call an outrageous statement about the emergence of a core commonality. Really! What do you think?

2) Discuss highlights and concerns from each of the core moralities:

Total Group Discussion

Discuss graceful aging.

a) Graceful Aging

b) Striving for Authenticity

c) Midwifery

After trio discussion
of B and C, discuss both
in the total group.

d) Commitment

After trio discussions, discuss
the four areas of commitment.

e) Being My Word.

After trios, discuss "Being
My Word" in the total group.

ESSAY 5: BEACONS FOR THE FUTURE

1) Discuss essay highlights.

2) Discuss whether you prefer the word *moralities*, *values*, or *myths*, or a combination.

3) What core moralities would you add? How would you rewrite the ones listed?

Total Group Discussion

Hear trio reports from Questions #1, 2, and 3.

4) Trios brainstorm ways to involve others in the building of core moralities.

• Identify groups or individuals
• Identify possible strategies

Total Group Discussion

Hear Question #4 ideas and strategies. Who will do what, with whom in a total-group strategy?

56

Groups with diversity (e.g., PTA, different faiths, etc.)
gather to develop core values,
even if some hold to "true belief" systems.

Among diverse groups there are some common values
which could first be identified and then discussed,
**toward the goal of supporting
values which enhance life**.

*We cannot afford to wait
until everyone agrees with the epistemology
(how we know what we know) of this book
to make this courageous step toward dialogue.*

CPSIA information can be obtained at www.ICGtesting.com
Printed in the USA
LVOW06s1229310815

452181LV00003B/22/P